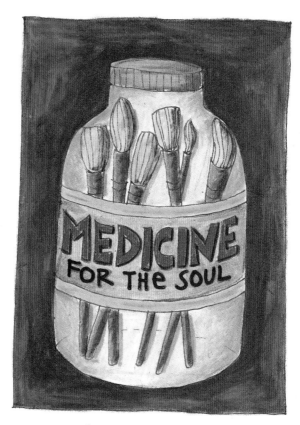

DISCOVER YOUR
OWN Medicine.

The SOUL SUPPORT BOOK

By Deb Koffman

FOREWORD

Things will come, things will go,
Sometimes quickly, sometimes slow.

Do not judge, Do not fear.
Simply LOVE, all that's here.

These tender words from Deb Koffman, whose friendship and artistry were taken from us far too soon, were among her many gifts to the world, gently inviting us to let her go as her illness progressed. Yet her undying spirit lives in the uplifting, soul-inspiring words and pictures she created to invite each of us to be present and to have the best day possible, every day.

She urged us to practice unconditional self-love. To accept what is. To remind us that it is okay not to know. To do nothing. To make mistakes. To change your mind. To experiment. She gave permission to be however we are feeling at any moment; to live mindfully.

Deb's words of support belied her years of struggle with depression, a driving force behind her writing, her art, her performance, her presence, her purpose. The Norman Rockwell Museum is deeply honored to welcome her illustrative work into its collection. Her art and Norman Rockwell's share an ethos. Each artist focused on the positive, saw the very best in all people, and forged their unique creativity through years shaped by the pain of depression and sadness.

Anyone who has lost a loved one knows that nothing can ever fill their absence. Artists achieve immortality as they leave so much of themselves in the world which continues to buoy those left behind; they inspire anew.

The abundance of love expressed in Deb's work, her message of radical self-acceptance, and her art of reframing any situation to see hope and opportunity lives on in *The Soul Support Book*, here published in a refreshed edition 20 years after its first printing.

The world needs a lot of soul support. Be kind to yourself. Spread love to all around you. Drink in these messages. Thank you, Deb.

Peace,
Laurie Norton Moffatt
Director/CEO, Norman Rockwell Museum

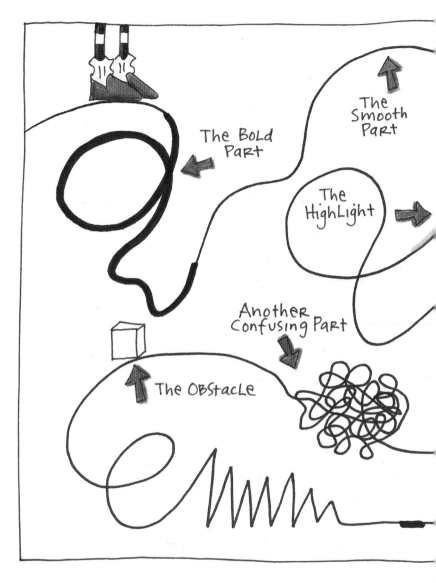

The BOLD Part

The Smooth Part

The HighLight

Another Confusing Part

The OBStacLe

MAP of the

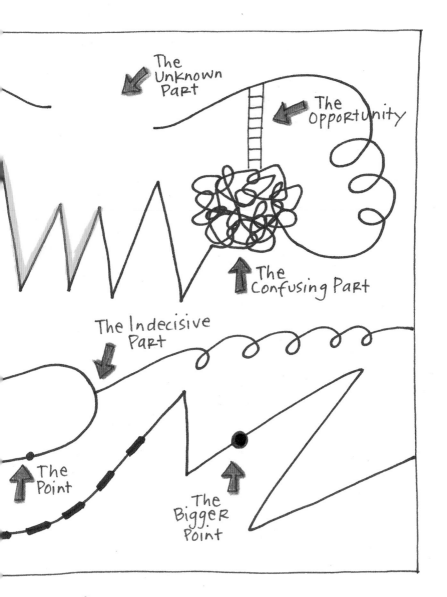

TeRRiToRY

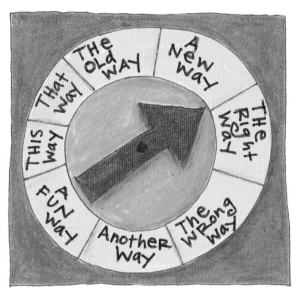

THERE'S ALWAYS ANOTHER
WAY.

INTRODUCTION

THIS Book IS about getting UNStuck. In YOUR creative projects, YOUR Job, YOUR ReLationShips, YOUR LIFe.

It's ABOut making where you ARe and what's Happening OK. Its ABOut THinking in A New Way.

It's ABOut getting A BROader View. It's about AcknowLedging what is TRue.

When you don't Know what TO DO, where to GO OR what to SAY...

ContempLating these cartoons may inspire you to PLAY... in YOUR own UNIQue Way.

THIS Book can Be Read. Seen. In any ORder. OR you can RandomLY peRuse.

Any page can be Tasted. FeLt. AS often aS you CHoose.

FOLLOW YOUR Intuition.

Speak A
Little

Speak A
LOT

Speak
Loudly

Speak
NOT

Sometimes
the words are
Down too Deep
To Reach.

When there Are No words...
Something ELSe WILL AppeaR.

HATE IT.

USE IT.

AVOID IT.

FACE IT.

FACE IT IN AN Interesting WAY

FACE it from A DiFFerent Side.

Speak to it.

Listen to it.

Go inside it.

Go beyond it.

See it as a gift.

See it as a mystery.

There are many ways to respond to the same thing.

Search for A Resourceful State.

see what
you wish...

see what
you fear...

See what
you THINK...

See what
is clear.

My Empty
Mind.

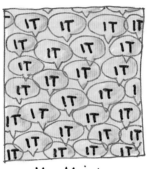

My Mind
Filled With IT.

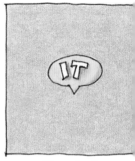

My Mind
Giving Space
To IT.

Don't THinkABout IT.

My Mind
STRaining To
Understand IT.

My Mind
TRYing to Resist
IT.

Letting GO
of It.

Watch youR mind.

IM

SIGHT.

Open to Something New.

It's NOT what it is...
It's What it INSPIRES
In YOU.

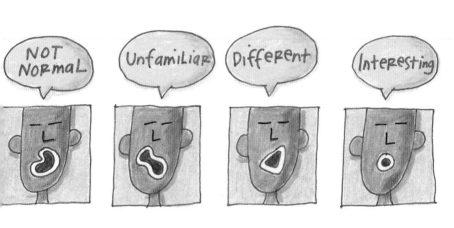

Be Genuinely Curious.

In the Past In a Littl

Recently

2 Months Ago

yesterday

Next Time

In a year

In a minute

Someday

3 years Ago Soor

While

BEFORE TOMORROW

 LATER

 Next Week

 ONCE

 Then

 In the Future

 WHEN

 10 Years from Now

 SHORTLY

 LAst Week

Notice what is Happening.

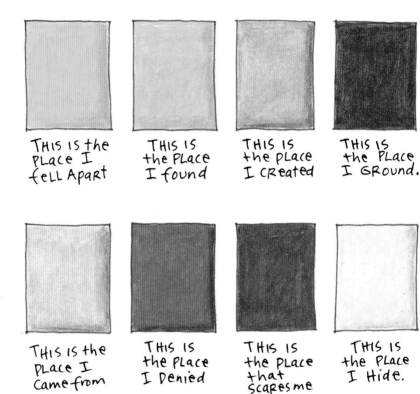

THIS IS the
PLACe I
fell ApaRt

THIS IS
the PLACe
I found

THIS IS
the pLACe
I CReated

THIS IS
the PLACe
I GRound.

THIS IS the
PLACe I
Came from

THIS IS
the PLACe
I DeNied

THIS IS
the PLACe
that
SCaResme

THIS IS
the PLACe
I Hide.

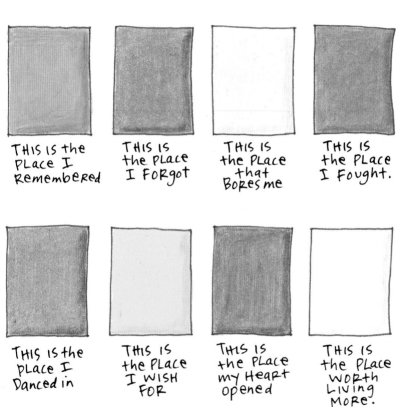

THIS IS the
PLACE I
Remembered

THIS IS
the PLACE
I FORgot

THIS IS
the PLACE
that
BoRes me

THIS IS
the PLACE
I Fought.

THIS IS the
pLACE I
Danced in

THIS IS
the PLACE
I WISH
FOR

THIS IS
the PLACE
my HeaRt
opened

THIS IS
the PLACE
WORth
LIVING
MoRe.

Appreciate youR Experience.

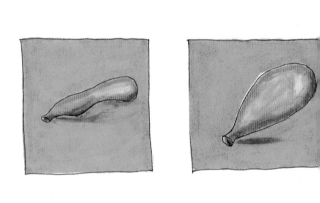

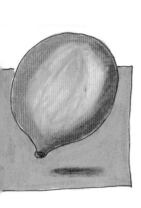

Concentrate on YOUR BReathing.

Being

Being with STRENGTHS

Being with Weaknesses

BEING WITH
PAIN

BEING WITH
PASSIONS

BEING WITH
HEART

Cultivate Compassion.

A GURU

A Teacher

A creative
Man

A wise
Man

A YOGI

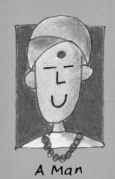

A Man

A Fallible
Man

A Human

Expand your Awareness.

In the Middle
of ALL the Stuff...
Spot A Precious
Moment.

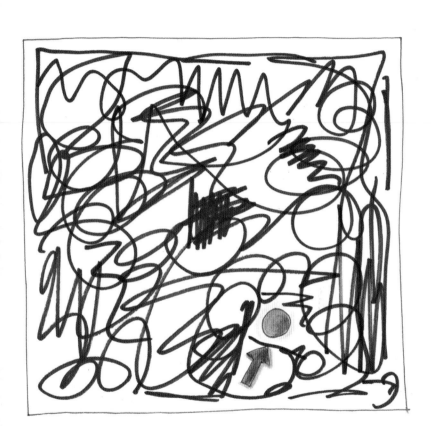

A Beautiful
Pink Moment

A Bright
Yellow Moment

A Deep
Blue Moment

A Small
Gray moment

A Mysterious
Green Moment

A Delicious
Red Moment

Honor every Moment.

Just
Listen.

ACt AS If It's Nothing...

ACt AS if It's Something
TO PLAY WITh...

Act As If It's Something
To get LOSt in...

Act As If It's Something
TO GO THROUGH.

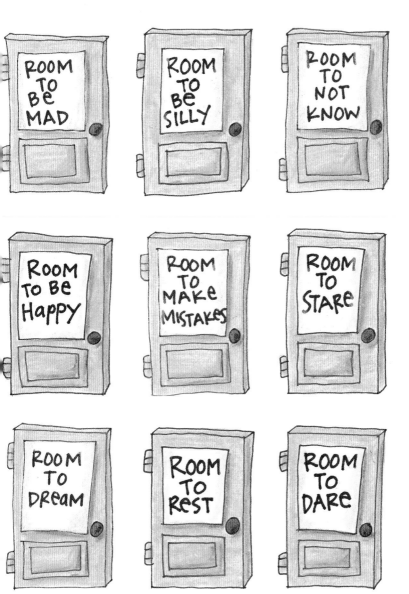

Make Room for What You Need.

FeeLing
Secure...

I found
the Courage...

To Have
the Faith...

To Express
my Joy.

Open your Heart.

Travel the Road in your own way.

When you
Can't Decide...
use your smile
as a Guide.

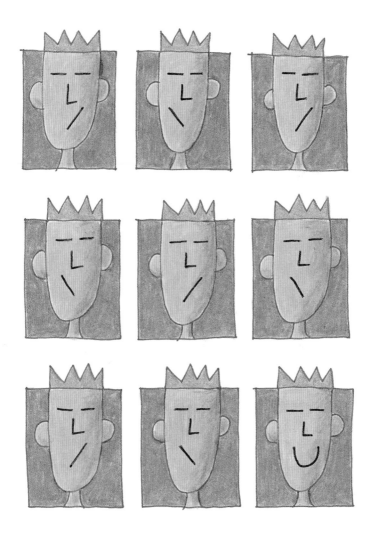

Explore Options.

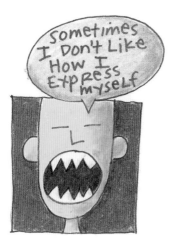

Accept who you Are
in this moment.

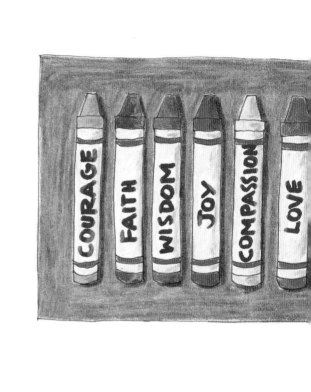

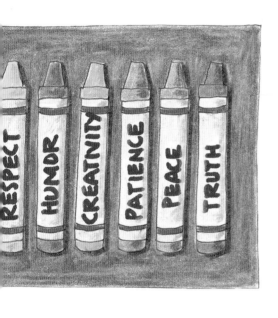

COLOR YOUR WORLD
With ALL that NOURISHES
YOUR SOUL.

Anything
IS PossibLe
Here.

EMPTY

SPACE

NOTHING

AVAILABLE

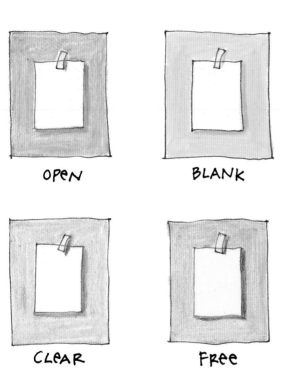

OPEN

BLANK

CLEAR

FREE

Changing Labels
Changes Possibilities.

Everything Happens
In Its own Time.

If what you're
Doing Isn't working...
DO Anything
Else.

IT'S OK TO NOT KNOW.

Practice Patience.

CRAZY PERSON
Going OVER
the Edge...

Rebellious
Person Crossing
BoundaRies...

CURIOUS
PERSON.
EXPLORING the
Unknown...

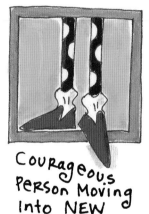

COURAGEOUS
PERSON MOVING
INTO NEW
TERRITORY

SEEK NEW PERSPECTIVES.

Look up. Look Down.
Look ALL Around.

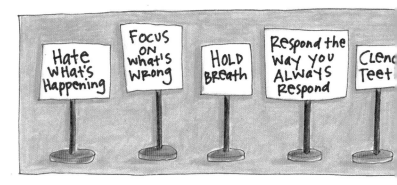

Signs of suffering...

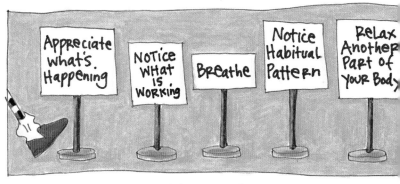

Signs of well-being.

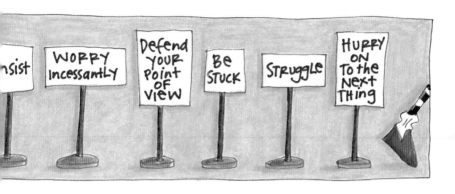

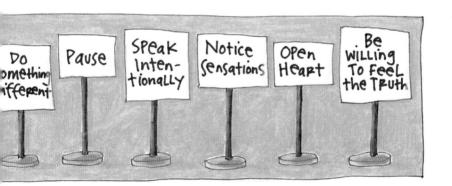

Notice
what lifts
Your
spirits.

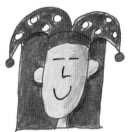

Changing Context
Changes Experience.

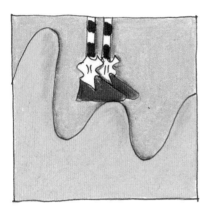

THIS IS WHERE
I STRUGGLED.

THIS IS WHERE
I LET GO.

THIS IS WHERE
I SOftened.

THIS IS WHERE
I KNOW.

Notice Sensations.

Sings in the
Shower

Cries at
Movies

Watches
Sunsets

Brushes
the Dog

Puffs the
Pillows

Gives
Back Rubs

Offers .
Free Advice

Makes Tuna
Sandwiches
on English
Muffins

Wraps
Presents

CHERISHES
DESSERTS

Reads Stories
OUT LOUD

Takes
Naps

GLUES
BROKEN PLATES

Smiles

Hugs

ARRANGES
FLOWERS

REARRANGES
FURNITURE

COLORS
OUTSIDE the
Lines

Acknowledge your Gifts.

Create
your own
Reality.

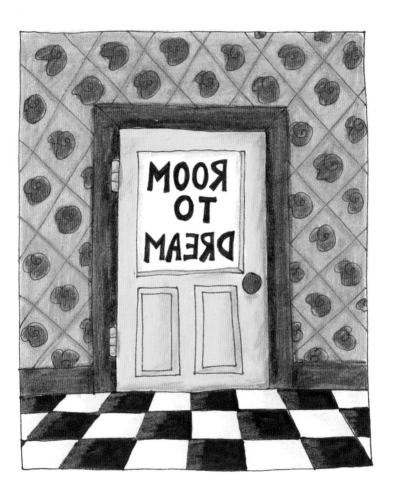

IT takes couRage to Step
Into the Unknown.

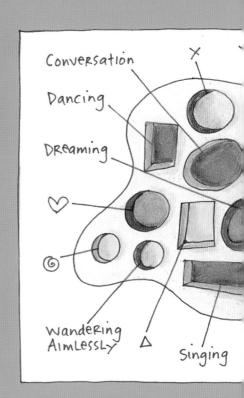

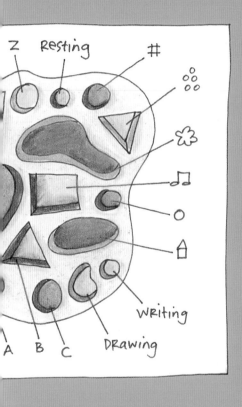

Z Resting #

Writing

Drawing

A B C

CARVE out Space
foR what you VaLue.

one view

Another view

Many views

overview

Right View

Opposing View

Scenic View

Re-view

Consider Another Point of view.

Notice
what makes
sense
NOW.

THEN.

WHEN.

NOW.

Sometimes I'm
JUST A BLOB.

Sometimes I'm
A REALLY BIG BLOB.

Sometimes I'm A
DARK and MYSTERIOUS
BLOB.

Sometimes I'm
ONLY PARTLY A
BLOB.

Sometimes I'm
A BLOB OF FUN.

Sometimes I'm
A PERFECT BLOB.

Sometimes I'm
An Insightful
BLOB.

Sometimes I
Disguise
MY BLOBness.

Witness yourself.

If you work
with It...
It WILL WORK
for You.

Beware of the
DARK...

Beware of the
Light...

If you choose
the DARK...
there is no Light

If you choose
the Light...

What was
Hidden ...

IS BRIGHT.

Be willing to feel
the TRUth.

IT'S NOT WHat it IS...

It's How
You ReLate
to It.

It's what
You compare
It to.

It's How It
can serve
You.

It's what
You can
Learn from
It.

It's YOUR
THoughts
ABout It.

It's the
Question
You ask
of It.

It's How It
Moves You.

It's what
You Believe
About It.

It's How
You Use
It.

It's the
context
You Put
It In.

It's what
It means
to You.

It's How
You Respond
to It.

The End is Just the
Beginning of Something
Else.

Believe
in
Miracles.

SAFE

CHALLenging

CERTain

Acknowledgments

To the many friends, teachers, Healers, And Books that have Supported my SOUL... my deepest gratitude for whatever Led me to your WISDOM.

To Storey Publishing... Deborah, Janet, Pam... for having the Courage to take a RISK on an unknown ARTIST... for Believing In me and my WORK.

To my mother, whose encouragement and wholehearted enthusiasm for my ART nourishes my creative Spirit.

To my Women's <u>Authentic Movement</u> Group... for your unconditional Love and Support. For the Space we Hold for each other's WELL-Being, personal Growth and Empowerment.

This Book is dedicated to Sam, Harry, ABE, Isaac, Genevieve and Billie... May you Always Listen to your Heart and follow what Supports your SOUL.

Edited by Deborah Balmuth and Mia Lumsden
Designed by Alethea Morrison and Ian O'Neill
Text production by Jennifer Jepson Smith

Storey Publishing
North Adams, MA
storey.com

Printed in China through Asia Pacific Offset
10 9 8 7 6 5 4 3 2 1

Library of Congress Cataloging-in-Publication Data on file